IMAGES
of America

ABERDEEN

This 1889 map clearly illustrates the exciting potential of a new town platted on the prairie. It shows Aberdeen at the center of at least 10 railway lines emanating from the community. This positioned Aberdeen as a major distribution hub for transportation of both people and goods. Industry boomed, first fueled by agriculture and then by diversified services and products. This map was taken from the *Daily Graphic* newspaper issue of April 11, 1889. The optimism of Aberdeen was heavily discussed in the media and contributed to Aberdeen being settled by business-savvy easterners—not cowboys or rustic pioneers. Notice that there was no distinction between North and South Dakota in 1889. Aberdeen was established in 1881, while South and North Dakota entered into the union in November 1889 (obviously after the drawing of this map). (Courtesy of the *Daily Graphic*, New York, April 11, 1889.)

ON THE COVER: This 1915 image shows a view looking north down Main Street as a parade of trucks steers clear of an oncoming streetcar. The large three-story structure toward the upper right is the Northwestern National Bank building, which was completed in 1889. This building has been lovingly preserved and now houses the Dacotah Prairie Museum. This photograph is from the author's collection, and it was discovered along with another picture that features the International Harvester building (page 102) and shows these same trucks parked alongside the building. The Union Bank building is in the lower left corner of the image, and the original Alonzo Ward Hotel is toward the upper left side of the image. The large Witte Hardware Store sign at right will be visible in many pictures throughout this book. The building still stands today, but none of the historic embellishments have been preserved; it currently houses Sander's Sew-N-Vac. Other than the Witte Hardware Store and Northwestern National Bank buildings, all other buildings pictured here on the right side of the street have been removed or replaced. (Courtesy of the author.)

IMAGES

of America

ABERDEEN

Troy McQuillen

ARCADIA
PUBLISHING

Published by Arcadia Publishing
Charleston, South Carolina

Printed in the United States of America

Library of Congress Control Number: 2012951001

For all general information, please contact Arcadia Publishing:
Telephone 843-853-2070
Fax 843-853-0044
E-mail sales@arcadiapublishing.com
For customer service and orders:
Toll-Free 1-888-313-2665

Visit us on the Internet at www.arcadiapublishing.com

As I become engrossed in a perpetual cycle of new things to occupy my life (such as this book), I am reminded that I do so with the loving support of so many people around me who are often neglected. Subsequently, I dedicate this book to my wife, Suzette, my mom and dad, Dave and Nancy McQuillen, my brother and sister-in-law, John and Jodi McQuillen, and my extended family in Aberdeen—Jeannie DeLine, Bill and Ev McQuillen, Dan McQuillen, and my great-aunt Berneil McQuillen. I should also include my poor dog, Riley, who never gets to play as much as he would like when I am busy. Thanks for the love and support, all; I need to go throw the Frisbee now.

CONTENTS

ACKNOWLEDGMENTS

For years, I have been collecting historic photographs from people who have stopped by my office. They willingly allowed me to scan their pictures for use in my publications so more people could see them. Unfortunately, I do not have notes from all those who contributed. I have also collected pictures from antique stores and the occasional rare find in a soggy basement. I would like to thank Sue Gates, from the Dacotah Prairie Museum, for several of its photographs, which are credited as (DPM). Shirley Arment, from the Alexander Mitchell Public Library, provided newspaper clippings and ephemera. Mary Worlie, from the Brown County assessor's office, provided access to the county's records, which are chock-full of historic pictures, primarily from the 1950s and 1960s; they are credited as (BCAO). Over the years, people like Ben Benson and Rich Korkel allowed me to scan their postcard collections. A lot of the detailed information would not have been included if not for the tireless research done by the late Don Artz and Dr. Art Buntin for many Aberdeen-related publications written for the Aberdeen/Brown County Landmarks Commission. These include *The Town in the Frog Pond* (Don Artz, 1991), *Brown County Courthouse, A Century Landmark* (Dr. Art Buntin and Nancy Aman, 2004), *Aberdeen Hagerty/Lloyd Historic District* (Don Artz, 1999), *South Main Street Changing and Changeless* (Dr. Art Buntin, 2007), *The Life and Times of the Dacotah Prairie Museum Building* (Don Artz, 2000), and the annotated 1907 publication *A Souvenir of Aberdeen* (reprinted in 1992 with a preface and commentary by Don Artz). Other references include *Brown County History* (Brown County Museum and Historical Society, 1980), *Early History of Brown County South Dakota* (Brown County Territorial Pioneer Committee, 1965), and the "Downtown Aberdeen Historic Walking Tour" brochure (Aberdeen/ Brown County Landmarks Commission, Dr. Art Buntin, 2003). William Lamont also provided some pictures. Thanks to Dillon Anderson for his help in scanning and retouching images. My sincere apologies if you sent me pictures that did not end up in the book—I ended up with a lot! Images throughout the book are attributed when the source is known; all other images come from my collection.

INTRODUCTION

The history of Aberdeen is very well documented. It was easy to get a hold of just about everything needed for the historic details included in this book. Unfortunately, there is not much room in this book for a lot of details. This is a book of photographs that are windows to what Aberdeen looked like in its earlier days, primarily in the central downtown business district. There was not room for neighborhoods, houses, sports, civic groups, wars, or events; that information is also easily obtainable, but it is not included in this book. Institutions like Northern State University, Presentation College, and St. Luke's Hospital are all omitted from these pages—they rightfully deserve their own books considering the impact each has had on our community. The intended focus of this book is on Aberdeen's architecture and the people who contributed to the look of the town. Alas, some of that information was not easy to find. So, while there are many pictures of historic Aberdeen, we still do not know much about the designers, architects, and contractors who created the city's structures.

When I was able to obtain large pictures, I scanned them at an extremely high resolution, which allowed me to zoom into very small areas of the photographs to reveal incredible detail not readily obvious to the naked eye.

The notion of the community of Aberdeen was conceived in Watertown, South Dakota, at the government land office. In early 1880, a group of men sat around a table, and one pointed to a spot on a map in southern Brown County; the pointing man was Charles H. Prior, townsite agent for the Chicago, Milwaukee, St. Paul & Pacific Railroad Company (also known as Milwaukee Road). The company was attempting to connect Bristol (South Dakota) to Bismarck (North Dakota) by way of Columbia in South Dakota. After pointing to the map, Prior proclaimed that this was where the Milwaukee Road would intersect the competing Chicago & Northwestern Railroad (C&NW) and was the place to plat a new town.

Prior could not get land rights through Columbia, however, and needed an alternative course. Columbia was the seat of Brown County at the time and subsequently played hardball demanding cash for the land rights for tracks and a depot plot; other towns willingly gave this sort of thing away to attract the railroads and the economic advantages that came with them. Columbia also demanded a drawbridge over the Jim River to accommodate steamboats. Prior did not approve, and Columbia lost out, as Prior invented his own town and bypassed Columbia.

In the summer of 1880, Ed Rice and Tom Boyden of Watertown set up a store where Prior had indicated the new town would be situated. They did so in anticipation of the intersection of the new Milwaukee Road line with the C&NW line. Intersections mean more people and more business opportunities. This new intersection became known as the community of Grand Junction or Grand Crossing, and a post office was established. Prior did not like the idea of including the C&NW in his new town, so he changed his mind and decided to move the town, Aberdeen, two miles north of Grand Crossing, far from the C&NW line in the middle of nothing but a slough.

When Prior made his announcement about moving the new townsite, Rice and Boyden moved their building to the new town location. They placed it in an area that eventually became the corner of Main Street and First Avenue Southeast.

The railroads liked the Aberdeen area because it was flat, allowing them to quickly develop into (and through) the city. Because of the four railway companies—Chicago, Milwaukee and St. Paul; Minneapolis and St. Louis; Great Northern; and Chicago and Northwestern—and their corresponding tracks (as many as 10 spoke-like rails), Aberdeen became established as a distribution point for nearby communities and other states. This caused many types of industry to move to and set up in Aberdeen.

How can a town that is randomly plotted have any sort of sustainable future? The railroads plotted towns about every 10 miles, and easterners coming to the area to take advantage of the surrounding farmland quickly realized the excitement of new towns. Aberdeen's self-proclaimed "Railroad Hub of Dakota" moniker earned it recognition as the center of Dakota Territory, and people wanted to be where things were happening. Other than fertile soil, Aberdeen has no natural resources; in fact, early artesian wells that supplied the city with water—a selling factor—soon became a major discouragement to development because the water was too hard for food and machinery.

Aberdeen was named after Aberdeen, Scotland, the home of Milwaukee Road president Alexander Mitchell. Many will recognize this name as the same name on the town's public library (see page 124). The town was established when land was officially made available for sale in the township area in 1881, but it was not officially incorporated until March 15, 1883. Aberdeen's biggest growth spurt came after 1910, when the population rose more than 160 percent and climbed to nearly 11,000 residents. Some suggest this bump was due in part to the fact that the Milwaukee Road had reached the West Coast, creating a transcontinental route through Aberdeen. The slow rise in population after this initial influx is speculated to be a result of the fact that pioneering was complete, the town was built, and business was business as usual. In fact, some believed in the 1920s that momentum seemed to cease once a formal government system and ordinances were introduced. People just kept moving west to see the next "new" thing. The population topped out in the 1970s at about 26,500. For whatever reason, Aberdeen has fluctuated around this number for 40 years, usually below it. Finally, in the 2010 census, Aberdeen's population once again exceeded the 26,000 mark.

In its early years (1881 to about 1920), with two major highways, an elaborate railway system, and an airport, Aberdeen manufactured and distributed candy, cigars, jewelry, radiators, baked goods, tire chains, books, lumber products, road machinery, tents and awnings, beverages, harness novelties, flour, sheet and heavy metal products, furnaces, automobile tops, butter, ice cream, optical goods, ice, monuments, and cement products. Items "jobbed" or warehoused and distributed through Aberdeen included groceries, fruit, drugs, hardware, tobacco, automobiles, tires, accessories, heating and plumbing fixtures, musical instruments, farm machinery, typewriters, adding machines, meat, cut flowers, cash registers, lumber, oil, office and school supplies, gravel, leather goods, grain, glass, billiard supplies, barber supplies, seeds, flour, and feed. Historically, growth occurs in cities after the establishment of transportation routes. But we still have all of these transportation opportunities today, if not more. So where did all these industries go? It seems odd that the city was once the hub of all this industry, yet it has changed dramatically.

In recent years, Aberdeen has conscientiously given up using the term "Hub City" in its economic development and community advertising. Previously it was splashed all over everything that left the community, including the back of the mayor's letterhead. Aberdeen was the Hub City because of the railroad. But transportation simply changed, it did not disappear altogether. If the community no longer believes in the Hub City mentality—the very thing that attracted others and made the town a magnet—then it will not be the center of anything. That said, the outlook is bright for Aberdeen; a lot of dedicated people are doing great things—a few could even be considered pioneers.

One

MAIN STREET VIEWS

1975

Downtown Aberdeen is resilient. It boomed, it flourished, it flooded, it failed, and now, it is rebounding. Aberdeen's core business district grew from the railroad tracks toward the south and two blocks on each side of Main Street. In the 1970s, many buildings still existed. In the early 1900s, downtown had spectacular buildings, a light rail system, and every product and service needed for an optimistic city.

It is hard to imagine massive snow accumulation such as this with no heavy machinery to remove it. This is an 1897 view of the west side of the 200 block of South Main Street looking north. Several of these buildings still stand today. This scene was dramatically changed after the addition of the six-story Citizens Bank building, which was constructed in 1909. (DPM.)

This is the corner of Third Avenue and South Main Street. This scene from the early 1900s shows the Appel building (224 South Main Street) at left. It was built in 1904 as a clothing store and is still standing today. A large crowd (and a dog) gathered for what appears to be a parade.

Main Street was definitely the center of Aberdeen, as shown in this image from the early 1900s. The structure at right is the two-story version of the Olwin-Angell department store. It still stands today, but it now has three floors. Most remember it as Herbergers or The Main Men's Store. The close-up below shows more detail of the 300 block. The Excelsior building (the large structure at left) was erected in 1887. On the right, a band is set up in the street as the crowd looks on. A few cars are visible in the distance. (Both DPM.)

This 1911 photograph depicts an Elks lodge ceremony. It shows the 500 block of Main Street looking northeast. The Dakota Farmer building at right, home of the Elks lodge, still stands. The one beside it is gone, and the other is the original Masonic temple. The First United Methodist Church is in the background.

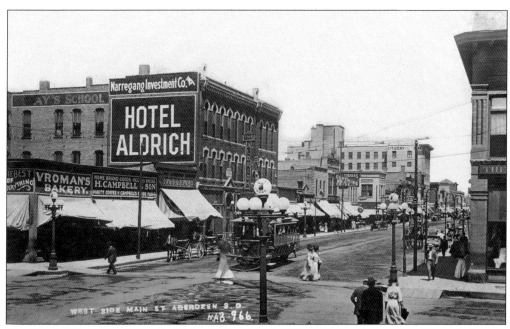

The Hotel Aldrich was located within the Excelsior building. This is the corner of Fourth Avenue and Main Street looking north. A trolley car suggests the picture was taken after 1910. Note the Elks lodge emblem on the streetlight in the foreground. (DPM.)

Two trolleys pass each other on the 100 block of Main Street c. 1910s. The six-story building in the background is the Citizens Bank building, and the building on the immediate right is the original Ward Hotel. This view is looking south. The Union Bank building (124 South Main Street) is just before the Citizens Building, on the corner; it still stands today.

Main Street, looking South, Aberdeen, S. D.

The streetcars entered Main Street via Fourth Avenue beside the federal courthouse and post office (401 South Main Street) c. 1910s. Here, it connected with Lincoln Street and continued south to Northern State University's campus. The large building in the lower left is the Sherman Hotel. The east side of the 300 block is in the center of the image.

This 1911 picture shows a lot of growth and development across the railroad tracks to the north in the 30 years since Aberdeen's platting. The large building in the center, which is still standing, now houses the Dacotah Prairie Museum. The street is busy with streetcars, horses and buggies, a popcorn cart, and pedestrians.

The close-up of the above image features the east side of the 10 block. An astute viewer can begin to decipher some of the names of the businesses, including the Bijou, Morrison Hotel, and Ladner Bros. Cream and Rye. All of these buildings are now gone.

This is another close-up of the 1911 image at the top of page 14. This is the corner of First Avenue and Main Street. Note the popcorn cart parked next to the Northwestern National Bank building. The building across the street is Lacey drugstore, one of the first buildings in downtown Aberdeen. The large pole in the foreground helped support the web of electrical wires that powered the streetcars.

The Excelsior building (at lower left) added a lot of class and sophistication to downtown Aberdeen. The Montgomery Ward building replaced it in the late 1930s (it was then home to Coast to Coast and is now Dacotah Bank). This 1910s image shows Main Street looking north. The Citizens Bank building in the background gives the scene a metropolitan feel.

This is a 1910s view of the intersection of Railroad Avenue and Main Street looking south. The tavern at right (with the Schlitz Beer sign) is the current location of the Flame Restaurant. Just beyond that is the J.B. Moore Furniture and Undertaking Store, which is now the site of the Wells Fargo Auto Finance building. Streetcar tracks run down the middle of Main Street.

Main Street, Aberdeen, S. D.

Stepping outside the front doors of what is now Dacotah Bank in the 1910s and looking north, one would see the view depicted in this postcard. The large brick building at right is the famous Sherman Hotel, which was built in 1908. This picture shows an interesting contrast between new large brick buildings and boomtown wooden facades still lining the street.

In this c. 1910s photograph looking north on Main Street, a parade advances past the 300 block. In the distance are the Sherman Hotel, Citizens Bank building (at left), the Appel building, and several others. This picture is labeled as "Elks Parade." A close-up (below) of the right side of the above image shows two distinct, ornate buildings. The first one includes an architectural feature known as an "oriel," or bay window. The building next to it is exquisitely designed with tall second-floor windows and a Victorian cornice on top (not visible here). Both of these buildings still exist and are just a few doors north of Webb's Shoes, but they now bear no resemblance to this picture. (Both DPM.)

Streetcars had to share the road with horses and wagons between the 1910s and 1920s. The building at right is the original Ward Hotel. The horse and wagon are parked outside the Northwestern National Bank (the current location of the Dacotah Prairie Museum building) at 23 South Main Street. This view is looking south, and one can see the Citizens Bank building toward the center. Zooming into the above image reveals many interesting details. The streetcars were connected to electrical wires overhead that were strung from buildings and poles along Main Street. A clock is in the background (see page 19). There is chain-link fencing on top of the Citizen Bank building, which delineated a rooftop courtyard. (Both DPM.)

This image is almost a reverse angle of the one on the previous page. This was a transfer spot for the streetcars; two streetcars are passing in front of the original Ward Hotel on the 100 block. The clock at left is actually a promotional item identifying a jewelry store. When Aberdeen redesigned the downtown streetscape in 2010, a clock very similar to this one was installed near this location. Zooming into the above picture reveals the name of the jewelry store, Voedisch Jewelry. All of these buildings are now gone. This location presently contains an office-supplies company and the old Sears building. Notice the gas light beside a newer electric light with an Elks lodge logo on the globe. The tavern in the white building is serving Anheuser-Busch and Faust beers.

Aberdeen So. Dak.
481 Scene at Street R.R. Transfer

This image looking north on Main Street shows two streetcars paused for a transfer and parked directly in front of what is now Sander's Sew-N-Vac on the 100 block. August Witte, an early Aberdeen pioneer who served as the town's mayor from 1892 to 1894, set up Witte Hardware Company (shown at right). The Dacotah Prairie Museum building is in the background. These streetcar attendants appear to be on a break, and a teenage boy enjoys an apple while leaning against a pole. A transfer point for the streetcar system was located here on Main Street. (Both DPM.)

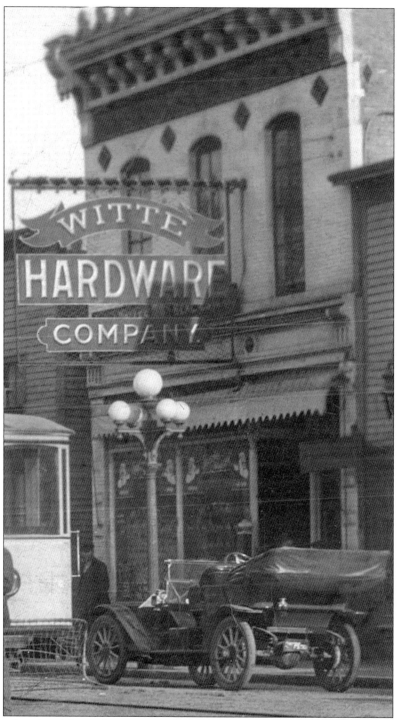

This is another detail from the image at the top of page 20. Aberdeen pioneer August Witte erected this building in 1898. The building still exists, and Witte signs painted near the back of the building are still visible from the alley. The building does not look anything like this anymore, and it is now home to Sander's Sew-N-Vac. (DPM.)

One of Aberdeen's most befuddling historic structures is the federal courthouse and post office (at right), which was built on the corner of Fourth Avenue and Main Street in 1907. It is commonly confused with the still-standing National Bank Building on the corner of Second Avenue and Main Street. The building was demolished sometime in the 1930s. Eventually, J.C. Penney relocated to this corner. Note the two-story Olwin-Angell building in the center. (DPM.)

This is a zoomed-in detail of the above image. The Idle Hour was a movie house located in the Jewett Block building, which was erected in 1887 on the southwest corner of Fourth Avenue and Main Street (the space is currently occupied by county health offices) and served as the Jewetts' wholesale grocery operation until they moved to a much larger warehouse on Railroad Avenue (which is still standing). (DPM.)

MAIN STREET LOOKING NORTH, ABERDEEN, S.D.

8003

In early 1900, Aberdeen's business district began to be filled with large brick "block" buildings. A block referred to a building that had multiple uses—retail, business offices, and residential. Nearly every building had a street-level basement stairway for access to additional businesses. This is the corner of Fifth Avenue and Main Street looking north. In the distance, the Olwin-Angell department store's new third floor is visible.

A closer look at the previous image shows the movie title *Sporting Goods* on the marquee of the Capitol Theatre. The Capitol Theatre was built in 1926 near the federal courthouse and post office, which is barely visible behind the large "Capitol" sign. The building on the immediate right is the 1917 F.C. Harms block, which sold pianos and furs.

23

This c. 1938 picture was taken on the corner of Fifth Avenue and Main Street looking north. As the large, illuminated blade signs began to project from buildings, Aberdeen took on a rather metropolitan feel. Imagine the chaser and neon lights illuminating the sidewalk on Saturday night when the farmers all came to town. The McDiarmid-Slater grocery store building, which still stands today, is at left.

This 1936 image features the west side of the 200 block. Several stores are visible: Dotty Dunn Hats, Lyric Theatre, Woodward Drugs, Blackhawk Dine and Dance, Plymouth Clothing, and Sears. Prior to permanent traffic signals, police officers had to direct traffic. Note that the traffic signal is portable, suggesting it was only brought out during busy times.

This 1938 picture, which is actually the right half of the image on the top of page 24, shows the busy corner of Fifth Avenue and Main Street looking north at the 400 block. The F.C. Harms building at right is still standing, the Capitol Theatre is now air-conditioned, and one can better see the newly added third-story on the Olwin-Angell building down on the 300 block.

Aberdeen's Main Street changed its traffic pattern and parking alignment several times. This late 1930s photograph shows diagonal parking and two-way traffic. The 300 block is at right, and one can get a good glimpse of the now three-story Olwin-Angell building at right. This department store grew into the building to the side of it and even into the next building, which now houses Webb's Shoes. (DPM.)

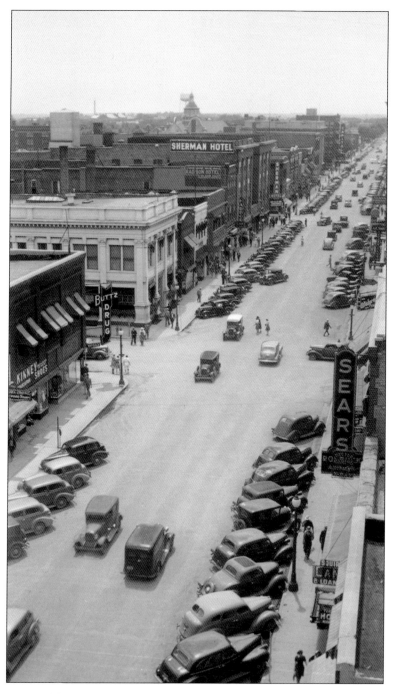

This image, presumably taken from atop the Ward Hotel sometime in the late 1930s or early 1940s, shows the intersection of Second Avenue and Main Street looking south. Today, this image would not look too different except for the large Sherman Hotel building, which was lost in the 1960s (see page 50). For some reason, the street looks very wide compared to today. Note that traffic is going both north and south and diagonal parking is still employed at this point. Buttz Drug, shown here at far left, is now currently home to the Natural Abundance Co-Op food store.

The large white building in the center was constructed in 1906 as the First National Bank. This building, which still stands today, is often confused with the federal courthouse and post office built two blocks down on the corner of Fourth Avenue and Main Street. This picture is an enlargement of the image at left.

This is a mid-1930s photograph of the corner of Fifth Avenue and Main Street looking north toward the 400 block. A parade is in progress, and the buildings have been decorated with bunting and flags. Notice that at the top of the Capitol Theatre building flags are flown from brackets that are still visible on the building today. The federal courthouse and post office is to the left of the Capitol Theatre. (DPM.)

This 1955 picture of Main Street shows two-way traffic, with second lanes added in both directions thanks to the return to parallel parking. The Sherman Hotel (right) has lost its decorative cornice along the roofline. The Citizens Bank building, however, still has its cornice at the top. Signage has become bulky and overbearing, suggesting a competitive need to grasp people's attention. When one zooms into the above photograph, one can really get a sense of the loud signage jutting from the buildings. Most of these buildings on the 200 block still stand today, even the Greek Revival Aberdeen National Bank building (second at left); however, it is covered with tin (former Preds Clothing building). By 1955, traffic lights had been installed.

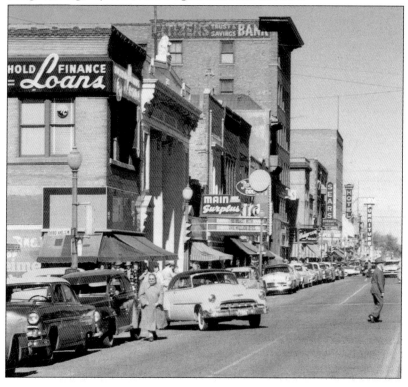

Two

MAIN STREET BUILDINGS

The Building and Loan Association (the three-story, Romanesque building in the middle) went up in 1891. The three-story building farther down—the Union Bank—was built in 1889. This photograph was probably taken soon after that. Note that the Citizens Bank building is not yet present—it was built in 1909 directly beside the Building and Loan. Downtown Aberdeen has always been in a constant state of flux, which is to be expected in a booming town. (DPM.)

The address of this building is 1 South Main Street, and it sat on the corner of Railroad Avenue and Main Street. Completed by Andrew L. Larson in 1905, the Commercial Hotel was the oldest downtown structure in continuous use for lodging. It housed a famous pizzeria when this photograph was taken in the 1960s. Many remember this building as the Bel Aire Apartments; it sustained substantial fire damage and was demolished in 2004. (BCAO.)

This building, constructed by John Moore in 1903 as a furniture store, was located at 8 South Main Street. Eventually, the Hay family acquired the building and continued to sell furniture until the property was sold and torn down to make way for the new Wells Fargo Auto Finance building in 2003. (*A Souvenir of Aberdeen.*)

The Hatz Block, built in 1905, was located at 24 South Main Street. It housed the Golden Rule department store until 1911, and it housed many other businesses before its demolition in 2002. Many remember it as Gambles, then as the Hay's World of Wood & Sleep Shop furniture store. The J.B. Moore building is visible down the street in this 1910s photograph. The close-up detail of the image above shows a mass of people shopping and hanging out. The men all sport hats of some type, and the women are immaculately dressed. Note the wooden plank ramps coming off the curbs. (Both DPM.)

This 1960 photograph shows the Hatz Block as Gambles department store. Some restyling was done to the building between the time of the image on page 31 and this one, including whitewash painting and covering the transom windows. This building was demolished in 2002. (BCAO.)

This image from 2002 shows the Hatz Block just before demolition. Modernization of the building continued up until it was torn down with the addition of stone veneer on the exterior. The upper floors were largely empty but once included a doctor's office and extra show space for furniture.

Most people know this wonderful structure as the Dacotah Prairie Museum building located at 23 South Main Street. Chicago investors built it in 1888 and named it the Northwestern National Bank. After many tenants and uses, the building, which was then nearly vacant, was donated to Brown County to be used as a museum in 1969. Much of the interior has been preserved or restored. (DPM.)

When the museum moved into the building at 23 South Main Street, most of the large picture windows were covered with corrugated metal that was not very welcoming. All of the windows in the building were replaced and modernized in a 2002 restoration. Great care was taken to preserve the original character of the building. This is a present-day picture of the Dacotah Prairie Museum.

Ward Hotel, Aberdeen, S. D.

This antique postcard depicts some interesting architecture for Aberdeen at 104 South Main Street. This is the original Ward Hotel, which was built in 1894. Alonzo Ward came to Aberdeen in 1883 with nothing and soon started a lunch counter. The Ward Hotel was the first to have a commercial ice cream freezer. This building burned down in 1926, and Ward completed the current Ward Hotel in 1928.

The Ward Hotel was the place to stay in Aberdeen after it was completed in 1928. It boasted a "fireproof" construction, meaning that it was built with almost no timbers but rather stucco, cement, and brick. This restored building graces the corner of First Avenue and Main Street. The simple architectural styling was probably the result of a need to quickly rebuild after a fire destroyed the first Ward Hotel on this same site.

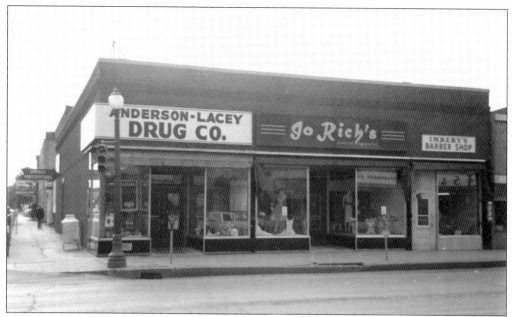

This building at the corner of First Avenue and Main Street may not appear all that interesting, but it occupies an important corner in Aberdeen's history. It was built in 1937 on the site of Aberdeen's first drugstore. The original wood building was brought in around 1881 from Grand Crossing (Aberdeen's original name), located about two miles south. The building, which can be seen on page 15, was known as the home of Lacey Drug and was eventually replaced with the brick one, shown above. (BCAO.)

The three-story building shown in this 1960 image still stands at 116 South Main Street. A stone marker on top references the building's original owner and date of construction: Van Slyke, 1916. Many will remember it as the Sears building, Aman Collection Service, True Value Hardware, and MicroAge Computers. (BCAO.)

This architectural illustration by L. Fleming of the Western Farm Mortgage Co. building was featured in an 1889 issue of the *Daily Graphic*. This structure, located at 124 South Main on the corner of Second Avenue and Main Street, is now known as the Union Bank building. The building was erected in 1889, but it looked nothing like this conceptual image (see below).

This is how the original Union Bank building, located at 124 South Main, appeared after completion in 1889. A few years later, additional ornamentation was added to the top of the building and the bricks were stuccoed over, perhaps to approximate the 1889 concept shown in the drawing above. Apparently, the fourth floor was never built. (DPM.)

In downtown Aberdeen, several buildings were often "banded" together with signage and wood or metal panels to make them look like one building. This is the case with the Union Bank building from 1889 (pictured on page 36). J.J. Newberry occupied this spot when this photograph was taken in 1960. This image shows the enhanced ornamentation added to the building sometime between 1907 and 1915. (BCAO.)

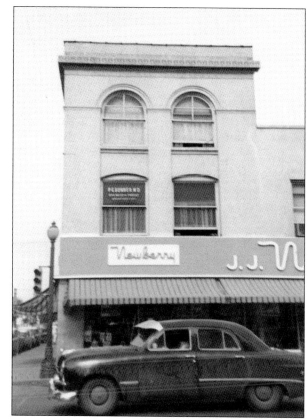

The building located at 119 South Main Street can still be found sandwiched between the existing Natural Abundance store and a recently restored building. In this 1960 image, many will not recognize the building, nor the business inside it, but it now houses one of the most recognized establishments in downtown Aberdeen: the Silver Dollar Bar. (BCAO.)

This building at 125 South Main Street is located at the corner of Second Avenue and Main Street. It was built as the Wells Block in 1898 for the Aberdeen Hardware Company. It has seen many face-lifts over the years in attempts to modernize its historic aesthetic. It is now home to the Natural Abundance store, which happens to be the only place to buy food downtown (aside from restaurants). Apparently, workers from the Aberdeen Hardware Company posed for the above photograph, as seen in the below close-up detail of the image. The Main Street access stairway for the lower-floor business is clearly visible behind the men. The "gas pipe railings" were a common site throughout downtown as every inch of a building was used for commercial retail space. Barbers often occupied the lower levels. (Both DPM.)

This architectural illustration, which depicts a new Citizens Trust and Savings Bank to be built on the corner of Second Avenue and Main Street, was featured in a 1909 Homecoming supplement to the *Aberdeen Daily News*. The building was finished in 1910 at 202 South Main Street and is still known as the Citizens Bank building. The illustration was done by Franklin Ellerbec, an architect from Minneapolis who worked a lot in Aberdeen.

Often, architectural concepts do not make it into or onto the final building. Compare the above sketch to the completed Citizens Bank building. Horizontal banding was emphasized in the sketch, but it did not really translate in the finished work. The roofline is also not as ornate as planned. When it was built, this was one of Aberdeen's tallest buildings; it boasted an electric elevator. (Ben Benson.)

This view of the Citizens Bank building shows the chain-link fence atop the building, which surrounded a garden restaurant that turned into a dance club in the evenings. A popcorn vendor's cart is visible on the avenue. This corner of the first floor of this building is now home to the Red Rooster Coffee House.

This image provides a more striking view of the newly completed Citizens Bank building. The Main Street entrance and Second Avenue entrance were both framed in concrete ionic columns. The Main Street facade has been altered to accommodate a corner entrance now used by the Red Rooster Coffee House and a completely different business on the south end. The Second Avenue entrance is still intact.

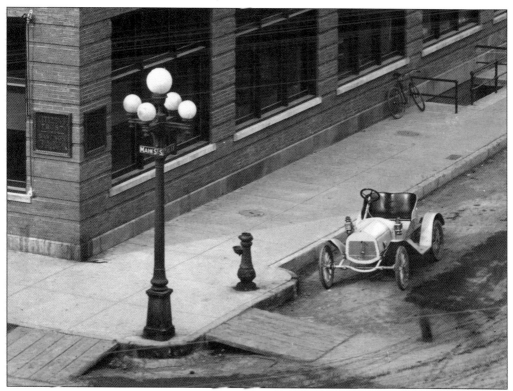

This detail of the preceding photograph shows several things of interest: the fireplug is ornately shaped and references modern city infrastructure, the car looks very new, and a basement access is visible toward the upper right. Today, the commemorative plaques adorning the pilaster have been removed, and all the windows along the Second Avenue side of the building have been bricked in.

Another detail from the image on the bottom of page 40 shows the stately entrance to the Citizens Bank building. To the left of the main entrance was a jewelry store called The House of Gallett LTD. All this detailing was removed from the building when the main entrance was moved to the north corner and a new business entrance was added where the store window is positioned.

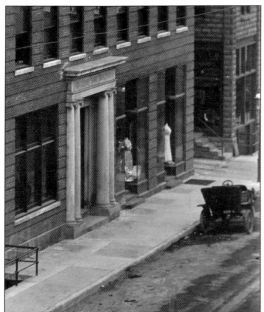

Around the corner of the Citizens Bank building were dress shops with their own entrances. Although the exterior entrances have been removed, the retail space remains. The one closest to the columns is now occupied by Ivey's For Hair salon; the other was a dental office for many years. The building beyond the alley is long gone.

The tall building in the shadows of this June 1911 image is the Excelsior building, which went up in 1887 and contained the Aldrich Hotel. In the distance at right, fireworks emanate from the rooftop entertainment complex at the Citizens Bank building. Downtown Aberdeen was a happening hot spot in its day. The electric lights hanging from the streetcar lines must have been quite a spectacle because as early as 1907 there were none. (DPM.)

This building at 206 South Main Street is currently occupied by a hair salon. This building was erected in 1891 as the Building and Loan Association, but it changed to First State Savings Bank sometime between 1903 and 1930. Many will remember this spot as R.E. Huffman's redwood-front office supplies store. Despite the coverings, many unique details are still visible today. (*A Souvenir of Aberdeen*, 1907.)

This illustration from an 1889 newspaper promotion for Aberdeen shows two early Main Street buildings. At left is the 1885 Aberdeen National Bank, which was located at 214 South Main Street and is now demolished, and at right, at 212 South Main Street, is the Fletcher & Fisher Real Estate office that was built in 1889. Fletcher's building is now home to Sammy's Restaurant & Omelette Shoppe and looks quite different. (The *Daily Graphic*, New York, April 11, 1889.)

In 1912, the Aberdeen National Bank moved from the stone structure at 214 South Main Street to this new location at 220 South Main Street. This Greek Revival–style building was finished with brilliantly white-glazed terra-cotta. However, in the 1960s or 1970s, much of the ornamentation was chopped away and a metal front was affixed to it—an appearance the structure still has today. Some elements remain behind the metal.

The Aberdeen National Bank occupied this spot at 214 South Main Street from 1885 to 1912. Note how businesses on the upper floors lettered their names on the windows. (*A Souvenir of Aberdeen*.)

In 1881, the Ringrose Colony, headed by James and Patrick Ringrose, emerged in Aberdeen. As early as 1881, James Ringrose built a small hotel on the corner of Third Avenue and Main Street. It was known as the Sherman House, and two years after it burned down in 1906, he built the hotel shown at right in the image above. The close-up at left reveals construction work on the new Firey block building at 211 South Main Street. J.H. Firey was a pharmacist. The 1912 Firey building now houses Engel Music and was recently renovated to resemble a historic facade. (Both DPM.)

Hotel Sherman, Aberdeen, South Dakota.

The Sherman Hotel was located at 223 South Main Street. After the original Sherman House burned down in 1906, a four-story replacement building was erected two years later. The north "tower" of this building burned in 1926 but was rebuilt in 1928. Various institutions took up business in the ground floor. This postcard is marked 1910.

Sherman Hotel, Aberdeen, S. Dak.

This postcard seems to be the same vintage as the one above. Note the trees growing near the right side of the image; they are nearly identical. This image shows a bit more traffic. The building to the left (north of the Sherman) was the Harbor Hotel. The Sherman met its unfortunate demise in the late 1960s (see page 50).

Another view of the Sherman Hotel at 223 South Main Street shows better detail in the architectural appointments. The windows are inset to create more shadow lines, adding textural interest to the flat walls of the exterior. The roofline cornice creates a short overhang, which anchors the building and adds a termination to the top. Zooming into the street-level view offers a sense of the detailing on the Sherman Hotel. Arched windows and leaded glass detailing add a flair of sophistication. The detail shows that the main entrance has been altered from a symmetrical layout to that of a large picture window and small doorway. The railing between the two main sections has also been removed.

This is another detail of the image at the top of page 48. The basement-level barbershop sign is barely visible at right. The leaded glass transom windows were certainly an upscale touch. Notice how the retracted awning is placed between the transom window and the picture window. This allowed filtered light to illuminate the interior from the transom even as the awning shielded goods in the picture windows.

This vintage photograph of the Sherman Hotel at the corner of Third Avenue and Main Street shows additional architectural details, c. 1920s. Note the upper portions of all the windows on the levels above the main level—they are comprised of diamond-shaped "lights" or divisions. The main entrance to the hotel was around the corner on Third Avenue.

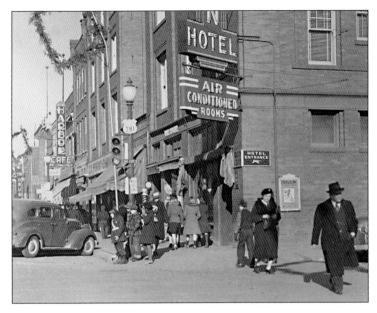

Comparing this 1940s close-up image of the base of the Sherman Hotel, located at the corner of Third Avenue and Main Street, with the image on page 49 reveals that the barbershop entrance on the avenue has been removed. A sign advertises the Orpheum Theatre, which was just down the block on Lincoln Street. A J.C. Penney sign is visible on the north tower facade. (Aberdeen Police Department.)

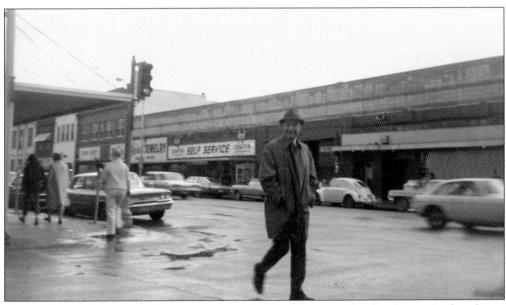

An association of downtown businessmen acquired the Sherman Hotel and conceived a scheme to convert it to a parking deck. In 1966, James Ringrose's famed Sherman Hotel disappeared. This is how it looked in 1969. To spur retail traffic in the downtown, developers removed the upper floors of the hotel, kept the bottom for commercial space, and built an elevated parking deck on top of what was left. In doing so, they also lopped off the upper floors of the adjoining Harbor Hotel. The parking ramp did not seem to work, structurally, and was demolished in 1977. An apartment building was constructed in its place in 1980 (aptly named the Sherman Apartments). (BCOA.)

J.C. Penney had several locations in downtown Aberdeen, including this one on the corner of Third Avenue and Main Street. This was built in 1925 and includes a very odd, oversized transom area of leaded glass. The tall transom may be a result of the rather tall ceilings inside, which accommodated a mezzanine level. The building is only 25 feet wide, but its 142-foot length extends to the alley.

After J.C. Penney moved out, the building remained a department store thanks to the Feinsteins. Just like Olwin-Angell, Feinstein's took over adjacent buildings and eventually attempted to link them with common design elements. This 1960 picture shows a modern storefront. The remodel deeply recessed the front door, creating more window area for displaying goods. The building still exists and is being lovingly cared for by the owners of Revive Day Spa. (BCAO.)

The address of this building, located on the corner of Third Avenue and Main Street, is 304 South Main Street. S.S. Kresge was a five-and-dime department store. The building was constructed in 1918 by Bryon C. Lamont specifically for the Kresge store, which operated there for the entire duration of the business's 50-year lease. In 1977, the S.S. Kresge Company was renamed the Kmart Corporation. (BCAO.)

This image also shows the Kresge building after S.S. Kresge Co. moved out and Jupiter, a discount store, moved in. After retail left this building for good, Dacotah Bank began using the building as part of its corporate offices. A desk lamp in the window perpetually lights the office in the upper right-hand corner, commemorating the memory of Vi Stoia, a prominent, successful city advocate. (BCAO.)

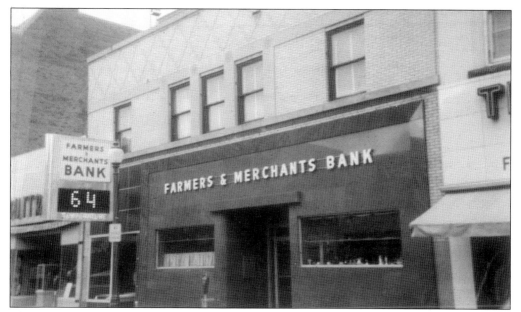

This bank was located at 308 South Main Street. Farmers & Merchants Bank was the predecessor to the bank now known as Dacotah Bank. The bank was established to serve both the business aspects of the community (the "merchants") and the agricultural side of the economy (the "farmers"). The names associated with this bank—E.C. Rhodes, Fred Hatterscheit, Robert and William Lamont, and Loel Lust—were crucial to Aberdeen's success. (BCAO.)

In this c. 1970 image, the famous Lu's Pizza delivery van is parked in front of the Farmers & Merchants Bank building. In attempts to be modern and stately, Farmers & Merchants Bank added large, white, aggregate "silos" to the fronts of two adjoining buildings in 1973. These silos were removed in 1993 and a historically inspired facade was built for Dacotah Bank's flagship bank in downtown Aberdeen. Dacotah Bank Holding Company owned Farmers & Merchants Bank and in 1995 changed it and all its banks' names to Dacotah Bank. (BCAO.)

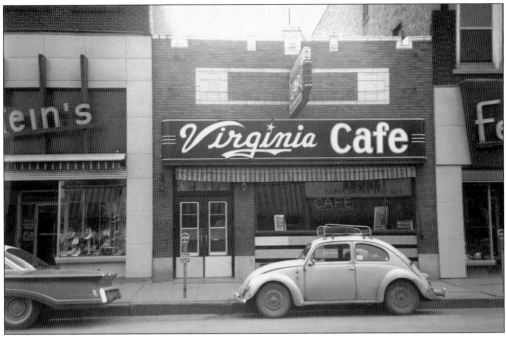

This 1960s photograph shows a small, nondescript building at 303 South Main Street—the Virginia Café—that was an icon and landmark for many generations. The Virginia was eventually covered up with wood to merge with the building at left. New Trends Office Supply occupied the two buildings for years. In 2010, all the wood was removed, once again revealing the quaint little shop space. (BCAO.)

Built in 1926 by John Combs, this structure at 307 South Main Street still stands almost entirely intact. It was built to house Combs Chocolate Shop, which could seat 225 people and offered an extensive menu of food and exquisite desserts. The upper floors contained a two-story dance hall that was later converted to a bowling alley. This space is now used as an indoor tennis court. (DPM.)

A look at this 1959 picture offers an idea of why shopping malls became popular. The Olwin-Angell store spread into one and a half buildings beyond its three floors of goods. This image shows the delineation of the original two-story version of the Olwin-Angell building (which was built in 1903) and the third floor addition that was added in 1914. The decorative columns were not repeated on the third floor. (BCAO.)

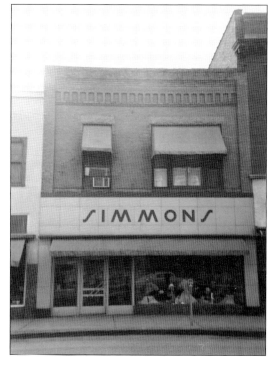

This 1960s image shows the Simmons store at 313 South Main Street. It was built in 1909 to house Griffs Drug Company and Goodale's Pharmacy. The original leaded glass transom windows are visible in the windows on the upper floor. Chunks of granite were used as lintels, and the same material is repeated just above the storefront. The enameled metal panels were removed in 2010 during restoration. (BCAO.)

Webb's Shoes was established in 1909. This structure was built in 1907 at 317 South Main Street, but Webb's did not occupy it until 1919. Ionic capitals on brick pilasters gracefully frame arched windows on the second floor. In 2013, all of the second-story windows were slated to be replaced with replicas of their originals. (BCAO.)

This Montgomery Ward building was erected at 314 South Main Street in 1938 on the site of the 1887 Excelsior block. This Georgian Revival style still maintains most of its character because the building has become part of the Dacotah Bank enterprise that owns the balance of the buildings to the north. Note the window-washers dangling from the windows on the front of the building.

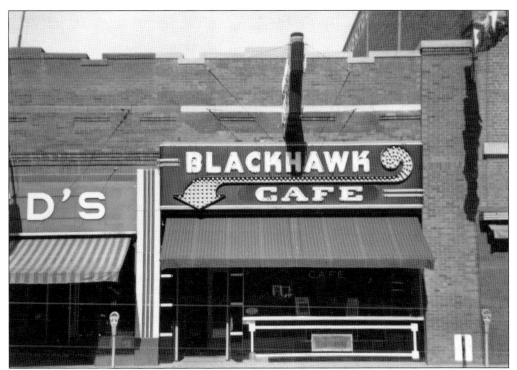

The very early pictures of Aberdeen's downtown show a lot of wooden, boomtown fronts on the buildings. As the town progressed, even simple, small storefronts were adorned with brick and modern coverings. This 1960 photograph of the Blackhawk Café, located at 318 South Main Street, shows a heavy, dominating sign with chaser lights and a lower portion covered with a colored glass knows as Vitrolite. (BCAO.)

This 1965 image shows Peterson's Café in the spot once home to the Blackhawk Café. The chaser lights and Vitrolite were kept. The county assessor dates this building back to 1887, however, it has undergone extensive changes in those 100-plus years. (BCAO.)

This late-1990s photograph shows the Olwin-Angell building on the corner of Fourth Avenue and Main Street. This was the location of Ben Franklin, Herbergers, The Main, and, most recently, Revive Day Spa. When Olwin-Angell replaced all the windows with glass block, it removed a lot of architectural texture formed by simply recessing windows a bit into openings, as seen in the image below. (BCAO.)

This 1959 picture of the Olwin-Angell department store still includes all the original windows on the avenue side. Notice how different the side of the building looks simply because of the window style. The first two floors of the structure were built in 1903, and the third floor was added in 1914. (BCAO.)

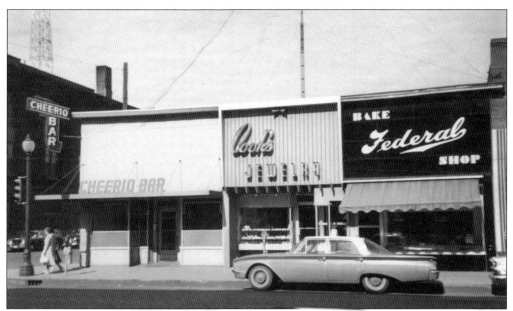

The Cheerio Bar shows up in several different downtown locations. This 1960 picture shows it at the corner of Fourth Avenue and Main Street, the location later occupied by Osco Drug. The Federal Bake Shop was completely covered with Vitrolite. At this time in downtown's history, many historic brick facades were being covered. (BCAO.)

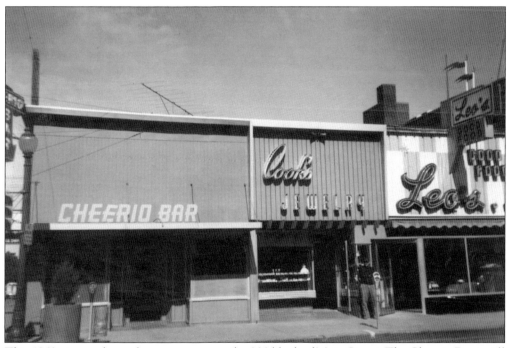

This 1963 picture shows the same corner—the 300 block of Main Street. The Cheerio Bar is still there (it later relocated to Third Avenue), but the Federal Bake Shop is now Leo's Good Food. The tin work of longtime vacated Cook's Jewelry facade still exists, but the Cheerio Bar was later replaced with Osco Drug, which is now Wild Oats Sports Bar and Grill. (BCAO.)

POST OFFICE, ABERDEEN, S. D.

In 1907, Aberdeen got its first official federal courthouse and post office building. Built in the classic Greek Revival style of many federal buildings, this graced the corner of Fourth Avenue and Main Street at 401 South Main Street. Many people confuse this with the still-standing First National Bank building two blocks north.

Another view shows the federal courthouse and post office. This time, however, the Capitol Theatre is visible in the background. The Capitol was built in 1926, which appears to be the vintage of this postcard. Oddly, this building had a relatively short lifespan; a new courthouse was built around the corner (on Fourth Avenue) in 1937, and this one was then destroyed.

This is the location that once contained the federal courthouse and post office at 401 South Main Street. After the courthouse was demolished in the late 1930s, the lot lay empty for several years. J.C. Penney was built as a freestanding structure on this spot in 1951. This building currently contains offices and one retail store. (BCAO.)

A year after J.C. Penney was built, Woolworth's relocated to the vacant space between Penney's and the Capitol Theatre. They were seamlessly joined, suggesting they were never built separately. This 1963 picture is no doubt showing downtown's famous annual Crazy Days shopping event. This spot is now occupied by Kathleen's Home Decorating store and by Dacotah Banks, Inc., on the upper floors. (BCAO.)

This building constructed at 402 South Main Street in 1887 was the home of Jewett Brothers Wholesale Grocers. Due to Aberdeen's distinction as a center of commerce, or "hub city," retail goods were in high demand beyond the city. The Jewetts abandoned this location in 1903 and built one of the warehouses that still exists on Railroad Avenue. The building next to Jewett Brothers was home to L. Frank Baum's Bazaar. An extreme close-up of the image above reveals two men. Another man is visible through the window at right. Notice the Masonic logo hanging off the balcony. This building has several commonalities with the Dacotah Prairie Museum building, which is of similar vintage. The divided light windows above the picture window are similar, as are the decorative arches and the panel design below the windows.

In 1903, the Jewetts moved out of their building at 402 South Main Street. Apparently Northwestern Public Service, the local electrical utility, took over the building, and the ground floor became a movie theater. Notice that the cornice has been "shaved" off the top of the building, leaving a scar where replacement brick was added—thus began the demise of this building. The detail below offers a better view of the area where the cornice once was. A brave soul is changing light bulbs or painting the sign. These ostentatious signs began to seep into downtown in the 1920s and 1930s and eventually dominated the streetscape with flashing lights and brilliant colors. Only one or two of them remain today; the most popular one, of course, is the Capitol Theatre marquee.

As with many historic buildings, constant "remuddling" can destroy the architectural integrity of the original structure. This image shows the once-magnificent Jewett Brothers Wholesale Grocers building on the corner of Fourth Avenue and Main Street with windows missing and a modernized retail facade covering half of the street-level floor. Its parapet has crumbled, potentially causing danger to pedestrians. (BCAO.)

The ailing Jewett building was eventually demolished and cleared for a new department store to rival J.C. Penney, which was across the street. This 1982 picture shows Bostwicks department store at 402 South Main Street; it was built in 1967. The building is still there, but it now serves as a county health office. Notice how traffic is now one-way, and parking has shifted back from parallel to diagonal. (BCAO.)

L. Frank Baum, the author who wrote the Oz series of books, came to Aberdeen in 1888 to set up an imported goods bazaar at this site at 406 South Main Street. However, he was not a very good retailer and eventually turned the store over to his in-laws, the Gages. This 1960 picture shows the Star Café and is not the same building as Baum's Bazaar. (BCAO.)

Most locals know this location at 502 South Main Street as Malchow's Home Furnishings. It was also the location of Aberdeen's famous Grain Palace, which was built in 1893 to celebrate harvests, display a plentiful bounty, and hold community events. The Grain Palace was designed by architect Edward Van Meter, who designed many courthouses, schools, and homes in the region. The Grain Palace burned to the ground in 1902 and was not rebuilt. (DPM.)

The Masonic temple was located across the street from the Grain Palace at 501 South Main Street. This modest temple was completed in 1897. The Masons did not build as large a hall as they wanted, because they could use the Grain Palace right across the street for large meetings. This was the fourth building in the country exclusively constructed for Masonic purposes. (*A Souvenir of Aberdeen*, 1907.)

In 1914, the Masons finished a complete remodel of the original temple building. This building still stands today, and passersby can appreciate the green space designed into the site. The building was extended and a hipped roof was added. All the brickwork was covered with stucco. Incidentally, Masonic temples are always built on an east-west axis.

This simple building at 511 South Main Street was built in 1923 for the Brownell Supply Company and was an Aberdeen landmark for many years. The Aberdeen Crockery was one of the most popular stores located here and was the place to go for fine china and gifts. It was located adjacent to the green space of the Masonic temple property. The Red Owl grocery store occupied this building in the 1930s. (BCAO.)

This late-1990s image shows the Crockery building and Taylor Music on the 500 block of South Main Street. Despite attempts by a local developer to buy the vacated Crockery and convert it back into a viable building, the decision was made to demolish it and turn the site into a parking lot for the adjacent First United Methodist Church, which owned the building.

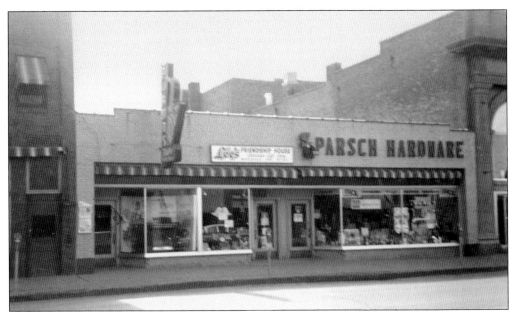

This 1960 picture shows a building with several businesses bridging the gap between the Crockery building and the Dakota Farmer building. This structure was erected in 1952 at 515 South Main Street. Taylor Music now occupies the entire building, as well as the Dakota Farmer building at right. All of these windows have been boarded up. (BCAO.)

This 1960 photograph shows a nondescript building erected around 1910 at 512 South Main Street. In 2009, two layers of exterior covering were removed, revealing this original brickwork. Unfortunately, the brick was pink and the owner—the Aberdeen Chamber of Commerce—did not care for the color. A historic facade was designed, the bricks were stained, bright red awnings were added, and this building is now a shining example of downtown revitalization. (BCAO.)

The two buildings located at 514 and 522 South Main Street are still there, however, they look nothing like they do in this 1960 image. The assessor's office lists their date of construction as 1910. Note that the farther one gets from the railroad tracks on the north end of downtown, the more nondescript the buildings become. These appear to be simply brick shells. (BCAO.)

This grocery store's structure was built in 1935 at 510 South Main Street. Though it has a simple design, it still shows an attempt at some style. This is the current location of Anchors of Faith, a spiritual book and gift store. The buildings on either side of Grove's still exist. (BCAO.)

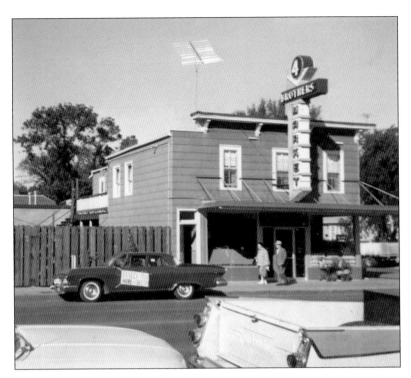

Leaving the historic downtown business district and continuing south on Main Street, travelers would pass the 4 Brothers Market on the corner of Seventh Avenue and Main Street. Not much is known about this building, but it still stands; however, it now looks nothing like this. (BCAO.)

Farther south, past the 4 Brothers Market, is the Dakota Farmer building at 1216 South Main Street. In 1911, this publication moved from its downtown location to these new headquarters. This building bears a resemblance to the Dakota Telephone Company on Fourth Avenue (page 86). This building has been preserved and is now an apartment complex. (Rich Korkel.)

Three

DOWNTOWN BUILDINGS

Taking a turn off Main Street in any direction, a person may wonder where all the buildings have gone. In the 1960s and 1970s, many off–Main Street buildings were purchased by downtown's parking association for demolition to make room for parking lots. Other buildings simply got covered up, as shown here. This is the backside of the Central Dakota Telephone Company (Bell Telephone), which is located near the corner of Fourth Avenue Southwest and First Street.

In 1890, Aberdeen won the county seat designation from Columbia. It was a long, drawn-out battle, with each town claiming the rights in the late 1880s. In fact, both cities built their own courthouses in hopes of permanently securing the rights. Aberdeen won out and began work on a new courthouse for Brown County. Construction on this community icon started in 1902 and was completed in time for a dedication by March 1904. In the close-up of the above image, a canopy of quickly grown trees shades a cannon and two large decorative boulders in front of the building. Also of note is the intricate wrought-iron fence (both the fence and the cannon were scrapped for iron during World War II) and the massive sandstone staircase leading to the rotunda.

BROWN COUNTY COURT HOUSE - ABERDEEN, SO. DAK.

This 1950s photograph of the Brown County Courthouse offers a look at the building in its prominent place in the heart of the city. Since the time this picture was taken, the courthouse has been surrounded with new buildings and substantial remodeling, forever ruining its character. However, the county has done a wonderful job retaining what character remains on the exterior. The close-up below shows the massive sandstone steps that were removed in 1974 as part of a major overhaul to the building. The rotunda space was also destroyed when an elevator shaft was placed right in the middle of the building. The remodeling was done to address and correct accessibility issues. These steps were a popular spot for bands and civic groups to pose for photographs.

Anyone familiar with the location of Clark Title Company—at the corner of First Avenue and Lincoln Street—will know where this building was located. This three-story building (with tower) was built in 1887 as the Kennard Hotel. It later became the home of the Aberdeen Chamber of Commerce and the Moose Lodge. (*A Souvenir of Aberdeen*, 1907.)

6765. Commercial Club Building, Aberdeen, S. Dak.

This postcard of the Kennard Hotel shows a bit more detail than the previous image. Note that it is annotated as the Commercial Club Building, which is similar to a Chamber of Commerce. This structure stood until 1965, when it was demolished to make room for the Clark Title Company building now in its place.

At 14 First Avenue, directly west of the Kennard Hotel's former location, is a smallish building that has seen many alterations over the years. It is visible in the two pictures on page 74, but in those images, it looks nothing like this. This structure is known as the Schwenk building, and the nameplate atop is dated 1911.

This is a fairly recent picture of the Schwenk building shown in the previous image. Many residents will remember this bar as Robies. The "brickwork" on the front and sides of the building is actually just stamped into the stucco. (BCAO.)

Lincoln Street, one block east of Main Street, was just as developed as Main Street. The Radison Hotel was located on the 200 block of Lincoln Street and was linked to the Sherman Hotel via a "skyway" over the alley. The building at right, one of the smallest in the book, still exists, while the entire Radison structure was demolished to make room for a parking lot. (Rich Korkel.)

The Radison Hotel shared a wall with the Orpheum Theatre near the corner of Third Avenue and Lincoln Street. This 1960s image shows that the Radison underwent substantial changes to its facade and now only included one entrance. The little building on the right is still there. Both the Orpheum and Radison were lost as part of the parking scheme of the late 1960s and early 1970s, in which the downtown parking association purchased buildings, tore them down, and replaced them with parking lots. (BCAO.)

This picture shows the staff of the South Dakota Wheat Growers. This building at 24 Second Avenue Southeast sits on the corner of Lincoln Street. It still stands but is part of a long, flat, one-story structure that has housed many businesses over the years. Note the basement access in front.

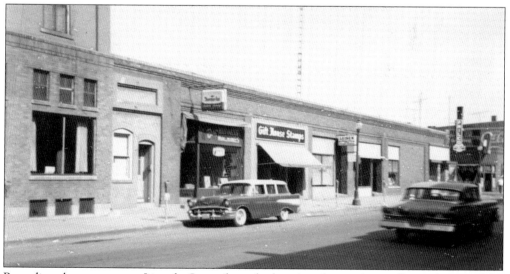

Rounding the corner onto Lincoln Street from the location shown above offers a glimpse of the rest of the buildings on the 200 block in 1960. The edge of the Radison building is still visible at left. (BCAO.)

This is same corner shown in the image of the South Dakota Wheat Growers on page 77. The addresses of the two buildings are 24 (left) and 22 Second Avenue. Many of the transom windows were covered over when the facades were "modernized." The name of the business on the corner is Danielson-Brost Company, a predecessor to the present-day Lang's audio, television, and appliance business on Sixth Avenue. (BCAO.)

Just to the west of the building above, at 18 Second Avenue, is this modern building for Pfeiffer's Furniture. The building was erected in 1931, but the facade is very modern in this 1960 image. The building still exists, but it now looks nothing like this. (BCAO.)

This 1915 building, located at 13 Second Avenue Southeast on the corner of Second Avenue and Lincoln Street, was across from the buildings on the previous two pages. Signage indicates that this is the 23 Club Bar; it shared a wall with the Herman Hotel to the north. Home Federal built a bank on this site in the 1970s. (BCAO.)

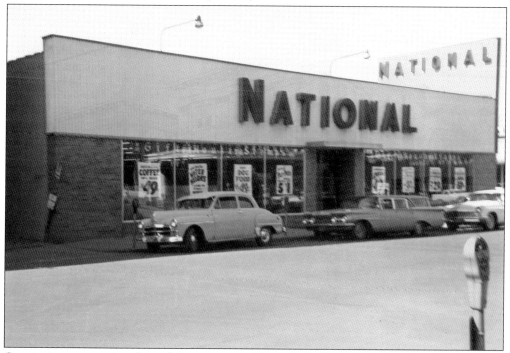

Continuing westward on Second Avenue, across Main Street, the Citizens Bank building is on the left. This grocery store at 19 Second Avenue Southwest would have been directly behind it, past the alley. This spot is now a parking lot affectionately known as the "Lagers Lot." (BCAO.)

This 1909 building located on the corner of Lincoln Street and Third Avenue Southeast was built for the Krogh's Grocery Store. Multiple buildings on Lincoln Street and the downtown avenues had corner doorways.

At some point, the grocery store disappeared, and this building turned into a liquor store. This 1960 picture shows the intricate brickwork on this building. This is also a great image looking south down Lincoln Street. The Oasis Bar sign at right is highly recognizable. The building burned and was demolished for a parking lot. (BCAO.)

This building at 24 Third Avenue Southwest is on the corner of First Street. Many will know this location as the Johnston Agency. This photograph was taken in 1964 and the building seems to be dated 1902. (BCAO.)

Anyone familiar with the downtown icon known as Lagers Inn may not recognize this as its location. This 1960 image shows 18 and 16 Third Avenue Southwest. The sign for Office Equipment, which occupied the spot near the alley, is barely visible at right. (BCAO.)

The 1960 photographs on this page show the same buildings—15 to 23 Third Avenue Southeast—from different perspectives. The large building in the background of the above image is the Orpheum Theatre, and the building at left in the picture below is the back of the Sherman Hotel. This corner dramatically changed in the late 1960s, when these buildings were replaced with a large ramp that led to an elevated parking deck that replaced the Sherman Hotel (see page 50). (BCAO.)

This building, constructed in 1930 as a bakery, still stands at 101 Third Avenue Southwest. This 1960 picture shows a Texaco filling station where there is now a Dacotah Bank parking lot. For a simple building, this has some interesting design elements that can still be seen if a viewer looks for them. (BCAO.)

The address of the building in the center is 20 Fourth Avenue Southeast. The building at left is the remnant of the Aberdeen American News building erected in 1909. The jewelry store at right was most recently Imberi's Barbershop; its building was finally torn down in 2012. The White Cross Cleaners building still stands. (BCAO.)

The Salvation Army took up residence in this building, which was constructed for the organization in 1913 at 14 Fourth Avenue Southwest. Dacotah Bank's drive-up now occupies this spot. This 1963 picture shows, once again, attempts to modernize a historic facade. This was usually done because the business inside did not need the large picture windows, which were also inefficient as far as energy purposes. (BCAO.)

The Greek Revival federal courthouse and post office on the corner of Fourth Avenue and Main Street was abandoned in 1937 for this new one located at 102 Fourth Avenue Southeast. Looking at a building from this perspective reveals the conscientious design elements that contribute to the uniqueness of the building.

This 1960 image shows the building located at 13 Fourth Avenue Southeast, approximately across the street from the White Cross Cleaners (shown on page 83) and directly behind the Olwin-Angell department store. County records show that this spot was developed in 1905, but Julius Huebl did not start his undertaking business until 1915 when he left the employ of J.B. Moore. The sign at the top of the building says "Huebl Block." (BCAO.)

Due to the nature of the one-way traffic on Fourth Avenue Southeast, this is how most view the courthouse and post office. This truly is an elegantly designed building and is now privately owned despite the fact a federal judge still occupies the top level. This picture shows the modern light fixtures near the entrances still wrapped for protection.

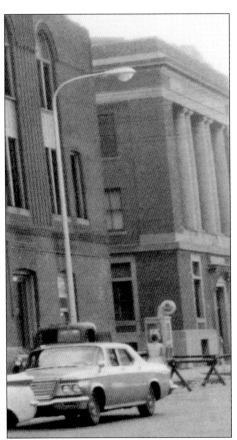

Returning back for a moment to the massive Jewett building on the corner of Fourth Avenue and Main Street, the background reveals an interesting building across the alley to the west—the Dakota Central Telephone building, which was erected in 1918. (BCAO.)

Here is a better picture of the Dakota Central Telephone building at the corner of First Street and Fourth Avenue Southwest. This stunning building with wonderful detail and classic attributes is still standing but has been covered up (page 87, top). Compare these design attributes with the Dakota Farmer building shown on page 70.

This modern image is included to show what has happened to the Dakota Central Telephone building. The original building, which is still occupied by a phone company, is "entombed" inside this structure. In fact, by viewing this building from behind or from the alley side, one can still see the original brickwork on part of the building (see page 71).

When the popularity of automobiles grew, so did the number of filling and service stations. Aberdeen's Sixth Avenue soon became a major artery for those driving through town on Highway 12. This Standard station, pictured in 1959, was built in 1950 at 101 Sixth Avenue Southeast—the corner of Lincoln Street and Sixth Avenue. This location is now a parking lot. (BCAO.)

The address of this building is 211 South Lincoln Street. The building was constructed in approximately 1910 and served as a car dealership for several years. This location became a parking lot, but it is now home to the new Aberdeen Public Safety building. The 1960 image above shows that it was a DeSoto and Plymouth Dealership; there is also a sign for Valiant Automobiles. Toward the far right edge of the photograph is a sign that says "Sherman Hotel"—this must have been a parking lot for the hotel. A close look reveals the Radison Hotel sign reflected in the second-story window at left. The photograph below is from 1965, and the dealership still sells the Plymouth brand. (Both BCAO.)

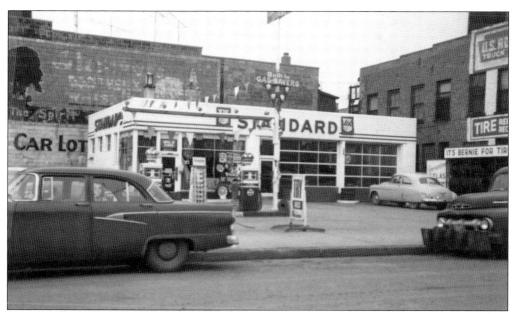

This 1959 picture shows a Standard gas station located at 320–322 South Lincoln Street. This is the west side of Lincoln Street, near the corner of Fourth Avenue. If the building behind the gas station was not there, the back of the Olwin-Angell and Webb's buildings would be visible. This is now a parking lot. The federal building is across the street to the east. (BCAO.)

This Mobil station at 219 South Lincoln Street was just a block north from the Standard station shown above. It is located adjacent to the building on the bottom left page. Note that almost every filling station at the time also had garage bays for service work. This picture is from 1959. (BCAO.)

Despite all the interesting cars, the most stunning aspect of this photograph is the bunting covering the courthouse in the background. This is the 300 block of Lincoln Street, looking north. Spaulding Auto (at right) was well known in Aberdeen for decades. The left side of the street displays some impressive structures that have all disappeared. The building behind the Aberdeen Laundry sign is the Krogh's grocery store shown on page 80. Zooming into the picture offers a better view of Spaulding Auto Company. Aberdeen had several brickyards during its developmental years, and they produced a yellow, common brick that was used on the backsides of buildings. The decorative facade of Spaulding Auto Company had leaded glass transom windows and was faced with a better quality brick than the yellow brick visible on the side. (Both DPM.)

The Herman Hotel, built in the mid-100 block of South Lincoln Street, was just down the street from Spaulding Auto Company. This long building was constructed in 1909 and is still in use today as a mixed-use office and residential space. The Kennard Hotel is partially visible just to the left of the courthouse. Note that the roofline is punctuated with decorative parapets, which have since been removed. (DPM.)

This is the same building that runs along the left side of the previous image. This 1963 photograph shows that the upper portion of the facade was removed. The building takes on a less interesting look without these elements breaking up the long lines. As is the case with so many downtown buildings, the current storefronts on this classic building do not reflect any design connection with the rest of the building, creating a disjointed look. (BCAO.)

City Hall, Aberdeen, S. Dak.

George Fossum was one of Aberdeen's greatest architects. He designed city hall, located at 123 South Lincoln Street, in 1913. The "municipal building," as it is called, is full of amazing detail. The doorknobs have a decorative letter "A" on them, the stained-glass windows on the west facade are outstanding, and the marble throughout is impressive.

As mentioned earlier, a lot of buildings in the downtown area have corner doorways. It was not certain what this structure was built for in 1903, but it is included simply for its quirkiness. It is across the street from city hall at 201 South Lincoln Street. Signage on the building reads, "Real Estate and Home Building and Loan Association." This is the current location of the new public safety building. (BCAO.)

This long lost building at 316 South Lincoln Street seems to have had many uses over the years. It is the building on the far left in the picture on the top of page 90, and on the right of the Standard station on page 89. It was built in 1902. This picture is from 1960. (BCAO.)

This automobile dealership was located at 106 First Avenue Southwest. It was built in 1956, and this photograph is from 1960. This would have been located near the base of the Second Street overpass just to the east on First Avenue. (BCAO.)

This is the corner of Fifth Avenue Southeast and Lincoln Street. This rare sight shows Lincoln Hospital and the Aberdeen Clinic side by side. The clinic building is still there, but the hospital has since moved several blocks away. This picture was taken sometime before 1926, as the YMCA is not yet on the corner; however, it appears the foundation has been started. (Ben Beson.)

As the Presentation Sisters continued to enlarge St. Luke's Hospital and their convent, additional space was sorely needed. In 1940, they purchased the Lincoln Hospital and opted to move it to its current location on Third Avenue Southeast and State Street. Even though it was only five blocks east, they had to devise a route that would accommodate the building. This image shows the building being moved past the Brown County courthouse, turning east onto First Avenue Southeast.

Here, Lincoln Hospital is at its new location at Third Avenue Southeast and State Street. Moving this structure required a monumental effort, and it is still remembered as an engineering marvel. It was put on wheels that rode on tracks that were laid, then pulled up, as the building moved along. Winches, horses, and tractors all helped to power the move.

Sears had a department store at 114 South Main Street, and this farm store annex was located a block west at 122 South First Street. This picture was taken in 1960. This building became the home of Student Loan Finance Corporation and, for many years, was planked over with wood. In 2010, the wood was removed and a new layer of brick was added to the surface all the way around the building. (BCAO.)

At the top, spread across these two pages, is a panoramic picture taken with a special camera in 1926. It features the Swanson Service Station which was located at the present site of Kuslers convenience store on the corner of Sixth Avenue and Main Street. The road in the image is Main Street, running north and south (left to right). The view is looking due west. The picture above shows a detail from the top picture. (Panoramic photograph courtesy of Richard Gooding.)

Looking through the overhang of the gas station in the top picture, one can see the Tiffany Laundry building. Toward the right is a beautiful building that is an auto dealer. The enlargement above reveals the make of the cars sold, Durant's Star Cars. Just beyond this building on the right is the building from the bottom of page 68. The W.H. Wilson Undertaker sign is still visible on south side of the Malchow building. (Richard Gooding.)

This Oldsmobile and Cadillac dealership was located at 112 South First Street. The building was constructed in 1925, and this photograph is from 1960. This is the area where the Student Loan Finance Corporation buildings are now. This was owned by the Johnson family, which also had a Fiat dealership around the corner. This building is now gone. (BCAO.)

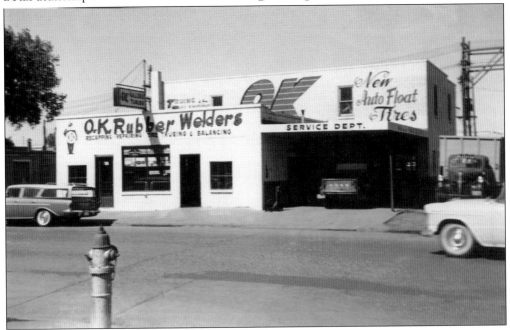

OK Tire was at 2 South First Street, just down the road from the Cadillac dealership in the picture above. The building is still there, but OK Tire recently went out of business. This picture is from 1960; county records show that this building was constructed in 1950. (BCAO.)

The Goodyear shop, pictured here in 1960, was located at 102 South First Street on the corner of First Avenue. In fact, the Cadillac dealership shown on page 98 is just to the left of this store. County records show this building was erected in 1948. (BCAO.)

Standard Auto Supply was located at 302 South Second Street on the corner of Third Avenue Southwest and South Second Street. This 1963 photograph shows what it looked like before it became a carpet store. Finishing Touch Design Studio, an interior decor and flooring business, now resides here. (BCAO.)

This building still exists, although it is no longer a Rambler dealership—in fact, it is not a car dealership at all; it is now a maintenance shop for the city. Biegler Auto was located here at 323 First Avenue Southeast. It was built in 1954, and this photograph was taken in 1961. The stacked brick design element behind the sign still exists. (BCAO.)

M&H gas station, pictured here in 1959, was on the corner of Second Street and Sixth Avenue. The gas station once had display cases of goods one could acquire by collecting green stamps. Compare this modest filling station to the one bearing the same name in this location today, dominating this busy intersection. (BCAO.)

This Cities Service Station was at 102 Sixth Avenue Southwest on the corner of First Street, next to the present-day Hardee's. The building is actually still there, although the metal panels and garage doors have been stuccoed over, and the whole place has been converted to a casino. This picture is from 1959. (BCAO.)

The coolest part of this stylish service station is that the building still exists on North Kline Street, just past Railroad Avenue. Its address is 2 North Kline Street. This 1959 image shows the building's strikingly Art Deco or Streamline Moderne style, yet it was erected in 1946, many years after both of those styles dominated architecture. (BCAO.)

The long line of trucks featured in the photograph on the cover of this book were headed toward this building owned by the International Harvester Company. This five-story building was constructed at 312 First Avenue Southwest sometime in the early 1910s. It eventually became the home of Hub City Iron, and this building burned to the ground in 1972. (Rich Korkel.)

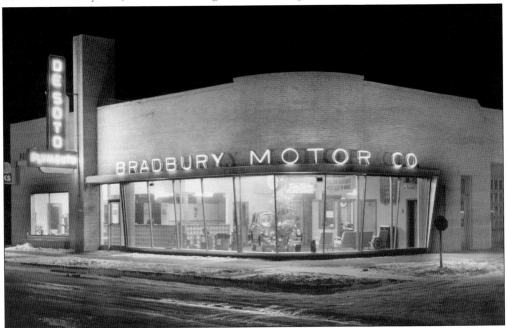

The building that housed Bradbury Motor Company still exists, but one would never know it as the present-day Shriners building on the corner of Eighth Avenue Southwest and Main Street. The windows have been taken out and a peaked roof was recently added. The picture windows of this building tilted out and curved around the corner, creating quite an elegant showroom. (DPM.)

Four

RAILROADS AND DEPOTS

Aberdeen's railroading past is too vast to adequately address here. However, the railroad was so important to driving Aberdeen's economy that it cannot be totally ignored. This is a picture of a material yard staged for transport by rail out of Aberdeen. Aberdeen became the "Hub City" because of its ability to get people where they needed to go but also by providing supplies and food for the outlying communities.

The passenger and freight depot for the Great Northern is located on Court Street just east of the courthouse. It was built in 1906 and still stands today. It has been preserved by the Richardson Law Firm, which has occupied it for several years. All the freight doors on the Railroad Avenue side are painted with old billboard-style advertisements that are now faint but still visible.

Visitors can ask permission to enter the parking lot of the Richardson Law Firm and check out the courtyard area. This is where the passengers boarded the train. This image shows passenger cars pulled up to the platform and the Brown County courthouse in the background.

This is the second depot built by the Chicago, Milwaukee & St. Paul (Milwaukee Road) railway company. It was located on the current site of what is now known as the Milwaukee depot at 1 North Main Street. The structure here before the one pictured burned down, and the one shown above burned down in 1911. The current building (pictured below) was built that same year.

This was the view from the upper floors of the Ward Hotel looking north. The structure with the large roof (top, center) is the present-day Milwaukee Road depot, which was built in 1911. Toward the left of that is the freight building, which has since been removed.

These people and goods are waiting to board the trains at the Chicago, Milwaukee & St. Paul depot. This view is looking east. This depot is famous for a canteen that was set up during World War II. The Red Cross used the canteen to make and distribute pheasant sandwiches to servicemen and women who traveled through Aberdeen. It served hundreds of thousands of pheasant sandwiches in only a few years. The image below is a close-up of the one above. The oncoming train is visible in the distance. Four or five sets of tracks once crossed Main Street at this point; now there is only one set. Some think the tracks served as the dividing line between Aberdeen's north and south sides, but the line is actually Railroad Avenue.

There do not appear to be many pictures of trains from Aberdeen's past, which is odd because the railroad was so critical to the community's development. This is a late-1930s view of the Milwaukee Road depot at 1 North Main Street. Below is a close-up of the steam engine. Coal was burned to create steam, which powered these massive engines.

This picture is almost identical to the one on page 106. In fact, it may have been taken moments before or after the other one. It shows linemen readying the area for the arriving train at the Milwaukee Road depot.

This is a reverse angle of the above image, looking west. Here, the caboose sports the name of the train—the *Olympian*—as well as the Milwaukee Road logo. The passenger area paved with brick still exists.

This is another westward-looking view of an arriving or departing train at the Milwaukee Road depot at 1 North Main Street. Given the vintage of the cars, it appears to be a bit older than the previous pictures. Note the row of implements at right. The close-up of the engine from the above photograph reveals details not readily seen in typical enlargements. Entering the engine number of this train into an online search engine helps one to find out more about the history and fate of the locomotive.

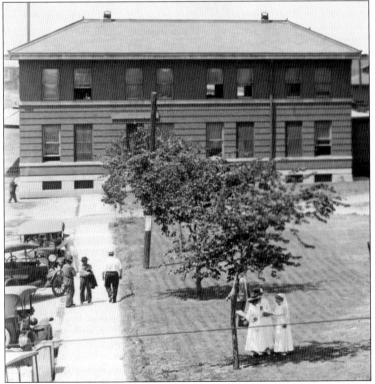

This is a photograph of some sort of civic gathering around the massive flagpole at the Milwaukee Road depot located at 1 North Main Street. Since it is such a large photograph, several enlargements have been made and are featured on the next few pages. The event name and exact year it occurred are not known, but estimates put in the 1920s. This building was known as the freight building. Note the group of nuns gathered in the shade under the young tree and the cars randomly parked in the depot parking lot.

This close-up of people leaving the gathering shows all the men wearing hats of some type and several women interested in the car or what is inside it.

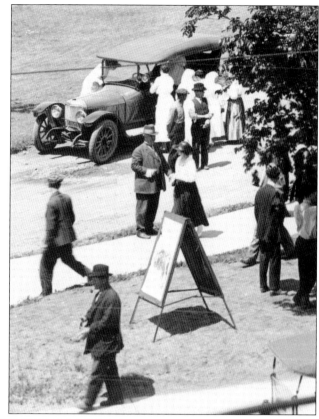

The Chicago, Milwaukee & St. Paul (Milwaukee Road) depot was built in a design known as Prairie style. This is recognized by a strong linear arrangement of elements parallel to the ground. The Prairie movement came from Chicago, and its influence is clear all around Aberdeen. One has to wonder what the gentleman in the middle of this image is up to.

A flip back to page 110 will reveal this train at the right side of the image. This enlargement shows a lot of residential development north of the tracks. Some of the houses may still be standing. A farming implement dealer is toward the right. Below, this final enlargement of the image from page 110 is actually almost the same view as above but zoomed in even closer. The engine is an even earlier model than the ones on previous pages.

Five

CHURCHES

When F.H. Hagerty and William M. Lloyd planned a new subdivision in Aberdeen, they donated land for schools and churches. The Hagerty and Lloyd's addition comprises 106 blocks from Sixth Avenue Southeast to Eight Avenue Northeast between Main and Dakota Streets. This view looks east on Fourth Avenue Southeast toward St. Luke's Hospital. The churches are (none of which are still standing), from left to right, Congregational, New Testament Church, and Norwegian Lutheran. (Ben Benson.)

The Bethlehem Lutheran Church building was designed by Aberdeen architect George Fossum in 1925. It was built on the site of the former Norwegian Lutheran Church at 215 Fourth Avenue Southeast. Bethlehem Lutheran moved out in 1997, and this building was razed in the early 2000s.

This church at 305 Sixth Avenue Southeast was built for the First Church of Christ, Scientist, in 1928. This building was also designed by George Fossum. In the early 1990s, the Bantz, Gosch & Cremer law firm purchased this building and completely repurposed the structure; thankfully, it still stands today.

First Methodist Church was located on the corner of Third Avenue Southeast and Jay Street. A new building was finished in 1909 (see page 117), and the church members left this one behind, but another congregation evidently took it over. It is no longer standing.

Before Sacred Heart Catholic Church moved into the beautiful current building on Third Avenue Southeast, it was located here. This was built near the same site as the current church in 1899, then condemned in the 1920s and torn down. The present-day church was finished in 1933. (Ben Benson.)

This beautiful church was located on the corner of Sixth Avenue Southeast and Lincoln Street. An addition to the east side of this building still exists today. This was last home to the South Dakota Wheat Growers, and it is now an office building. This was the First Baptist Church.

This building was constructed in 1882 as the First Presbyterian Church. In 1896, the Presbyterians sold it to Zion Lutheran, which moved it to 307 First Avenue Southeast. Fortunately, the building still stands at that location; it is owned by a painting business that uses it as a shop building.

A comparison of many of these church buildings reveals a similar architectural styling referred to as Moorish, or Byzantine, that is punctuated by arched walls, cloverleaf windows, round towers, and arched windows. The First United Methodists began building this church in 1908. Thanks to a growing congregation, the building has been remodeled several times. The close-up of a person sitting on the high curb is included because it shows the back of the Alexander Mitchell Library, which was built facing Sixth Avenue in 1901 (page 124).

The Calvary Chapel Church at 321 North Lincoln Street also displays a somewhat odd architectural style. It has a Moorish flair, predominantly in the tower and round windows. This church was built in 1918 by the Wesleyan congregation. Shriver's mortuary was to the east behind it.

This vintage photograph shows St. Mark's Episcopal Church, built in 1887 at 22 Sixth Avenue Southeast on the site of the Red Owl building (now Geffdog). It was used until the congregation relocated farther north in 1961.

St. Mary's Catholic Church was built at 201 North Arch Street in 1903. The congregation moved into a new, second building in 1941 and converted this into a parish hall; it no longer exists. This parish was established for German-speaking Catholics and is located in the area where many Germans settled in Aberdeen. The close-up at right is included to show the scale of the sanctuary relative to the size of the people. At first glance, the picture above may seem to show a small, rural church in the countryside, but this church was substantial. Note the crosses on the small dormers on the steeple.

FIRST PRESBYTERIAN CHURCH
ABERDEEN, SO. DAK.

The First Presbyterian Church, built in 1927 by Aberdeen architect George Fossum, is one of the grandest churches still standing in Aberdeen. It is located at the corner of Fourth Avenue Southeast and Kline Street. Like Fossum's Bethlehem Lutheran Church (page 114) formerly located just a block west, this building is also asymmetrical. Since they both occupied corner lots, Fossum accentuated the visual weight of each building to the street corner, seemingly anchoring the structures to the intersection with their bell towers.

This building was purchased from the First Wesleyan Methodist Church by a newly formed Jewish congregation in 1916. In 1917, the B'Nai Isaac Synagogue was established by Isadore Predmetsky, Ben Brussel, Sam Calmenson, and William Ribnick. In 1950, the tower was removed when the building underwent major renovations. The B'Nai Isaac Synagogue is still located in this original location of 202 North Kline Street.

Six

ARCHITECTURE AROUND TOWN

ABERDEEN, S. DAK. JEWETT BUILDING.

There was a time when any building, even if it was a wholesale grocery warehouse, could be built with flair and pride. When Aberdeen was booming, it seemed every businessman wanted to shine, and he built things to make the city proud. This is the second Jewett Brothers Wholesale building erected in Aberdeen. It was built in 1903 on Kline Street and Railroad Avenue, adjacent to the railroad tracks, and it still stands today.

This five-level apartment building, Dorian Flats, was built on the corner of Seventh Avenue Southeast and Lincoln Street. Its design is complex and loaded with style and character. The building still exists and has endured many brick failures and general deterioration. Fortunately, it is maintained and inhabited. The stately porches on the front and side have been boxed in, however.

This is the Civic Auditorium Arena, a classic example of Streamline Moderne architectural style that was built in 1938 as a Public Works Administration project. It is located at the corner of Washington Street and Second Avenue Southeast. Unfortunately, the ribbed windows on the front have been filled in, but everything else is intact. This building hosts the circus every year.

This building located at 418 South Second Street still stands today. However, one will not recognize it in these surroundings in this picture. It was moved. This picture was taken in 1960 at the building's original location at First Street and Fourth Avenue Southwest. The building is an excellent example of the Streamline Moderne style of architecture popular in the 1920s to 1930s. This building was built in 1941 as a Dairy Bar. (BCAO.)

The same Moorish design of some of the churches featured in the previous chapter can be seen here on the Adams school building at 204 Seventh Avenue Southwest. Aberdeen's many schools were built from similar plans and designs, and other examples of this style include McKinley School and Garfield School, which had hipped roofs instead of the arched wall facade. They have all been destroyed. (BCAO.)

Aberdeen's Alexander Mitchell library opened at 19 Sixth Avenue Southeast in 1901. It was built with a $15,000 grant from Andrew Carnegie. It was located at the spot now occupied by an addition to the First United Methodist Church. Mitchell, the president of the Chicago, Milwaukee & St. Paul Railway, was Carnegie's friend and customer, so Carnegie allowed the building to bear his name. Mitchell hailed from Aberdeen, Scotland.

The Howard Hedger public elementary school building was constructed at 210 Eighth Avenue Northwest in 1939. One identical to it, O.M. Tiffany, was built several blocks east on the corner of North Dakota Street and Eighth Avenue Northeast. In the early 2000s, a developer converted a portion of the Howard Hedger school to serve as a corporate headquarters. O.M. Tiffany Elementary is still used as a school. (BCAO.)

This 1883 picture, included for contrast, shows early "boomtown" businesses along the east side of the 10s block of Main Street. It shows a dirt Main Street and a wooden sidewalk, as well as a bank, a real estate office, a jewelry store, a general merchandise store, and a newsstand. (DPM.)

This, the Shuler Block, must have been one of Aberdeen's most ornate buildings. It was probably built in the late 1880s. There is no indication of where it was located, but it is visible in the distance near the railroad tracks in an unpublished picture of Main Street. It could possibly be the location inhabited by the Flame Restaurant. The bumped-up tower was probably intended to attract those disembarking from the trains. (William Lamont.)

SHULER BLOCK.

It was always Aberdeen's intent to host a smashing county fair. These drawings outline plans for the Tri-State Fairgrounds to be built on the site of the present-day Brown County Fairgrounds sometime in the early 1920s. The Tri-State Fairgrounds first opened on September 5, 1921. North Dakota, South Dakota, and Minnesota were represented at the fairs, which lasted until the Depression. In 1933, the Tri-State Fair Association was foreclosed upon, and after taking control of the land, Brown County held the first Brown County Fair in 1935. Note that the plans contained an air field. (Both, Library of Congress.)

This is the only residential house featured in this book. It is known as the Milligan house and was located at 519 South Kline Street. Albert Milligan was the president of the Alexander Mitchell Library, and after he passed away, his son donated this property for use as a new library. In the early 1960s, the house was moved to an area near the airport and was used as a museum for a time. Weather finally took a toll on the house, and it fell into disrepair. In the mid-2000s, the city attempted to tear it down. A buyer stepped in, however, and stabilized the house and hauled it out of Aberdeen. The 2012 image below reveals the house in a questionable state in the middle of a field, discovered during a pheasant hunt. (Above, Ben Benson; below, Aaron Kiesz.)

DISCOVER THOUSANDS OF LOCAL HISTORY BOOKS
FEATURING MILLIONS OF VINTAGE IMAGES

Arcadia Publishing, the leading local history publisher in the United States, is committed to making history accessible and meaningful through publishing books that celebrate and preserve the heritage of America's people and places.

Find more books like this at
www.arcadiapublishing.com

Search for your hometown history, your old stomping grounds, and even your favorite sports team.

Consistent with our mission to preserve history on a local level, this book was printed in South Carolina on American-made paper and manufactured entirely in the United States. Products carrying the accredited Forest Stewardship Council (FSC) label are printed on 100 percent FSC-certified paper.

MADE IN THE